POCKET PAINTERS

WHISTLER

1834 — 1903

Whistler

James Abbott McNeill Whistler
(1834-1903) was born in Lowell,
Massachusetts, but spent most of his
childhood in Russia. When his
prospects of a military career ended
in academic failure at West Point, a
spell as a cartographer on the US
Coastal Survey, during which he
learned the art of etching, changed
the course of his life.

In 1855 he moved to Paris, where he
entered the studio of Charles Gleyre

and became friendly with Courbet and Fantin-Latour. French Realism greatly influenced his painting over the next few years, when he also devoted much time to etching, a medium to which he would frequently return. Four years later, rejected by the Salon, Whistler moved to London and exhibited at the Royal Academy.

From now on his time was mostly divided between London and Paris for the rest of his life. In the 1860s a strong attraction to Japanese art led Whistler away from realism and towards highly individual 'arrangements' of tones and colours, first in portraits and figure studies, then in his ravishing nocturnes of the Thames, which he painted in his studio from memory, planning each canvas meticulously and preparing his tones on the palette.

The critics were angered by the ephemeral and, to them, unfinished look of the paintings, and the quasi-musical titles he gave them. Whistler's defence of his work did nothing to appease them. The arrogance with which this dandified little foreigner rejected the basic tenets of Victorian paintings was too much for Ruskin, who made the mistake of insulting him in print. Whistler duly sued, and won a Pyrrhic victory, receiving a farthing in damages at the end of a famous trial which divided the art world, greatly entertained the public and forced him into bankruptcy. If his later output generally failed to match the brilliance of his work up to this point, it is possibly due to the energy he expended in pursuing his enemies and promoting his reputation on both sides of the Channel.

A renowned wit and a pugnacious self-publicist who never bothered whom he offended, Whistler always made good copy. What only became clear in retrospect was that by moving freely between the artistic circles of Paris and London, associating with Realists and Pre-Raphaelites, Impressionists and Aesthetes – while remaining committed to nothing except his own vision – the cosmopolitan Whistler did much to overcome the insularity of English painting. Through his rejection of subject, story and symbolism in favour of virtually abstract harmonies of tone and colour, he also gave a significant push to the artistic revolution that was gathering momentum as the century drew to its close. ◼

*Harmony in Green
and Rose:
The Music Room*

Oil on canvas
1860 – 1
95.5 × 70.8 cm

According to Walter Sickert, writing
in 1892, this early work showed that
Whistler's qualities as a painter had
been *'invariably present through all the
different stages of his strange and versatile
development.'* Sickert drew attention to
*'the unerring hand of the etcher in the
drawing of the patterned curtains, the
divine eye for colour…'*

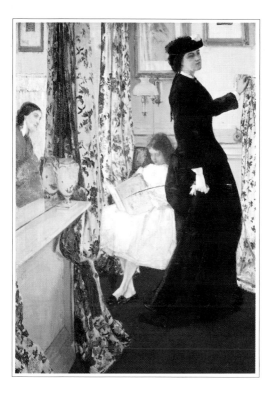

***Figures on a
Beach near Cliffs***

Pastel
1860
46 × 32.5 cm

Although a master of pastels, as of
etching, from an early age, Whistler
produced few pastel landscapes before
his visit to Venice. This richly coloured
beach scene, probably dating from a
visit to Brittany, shows him applying
colour thickly. Later he would use it
sparingly, relying on coloured paper
to provide an overall harmony.

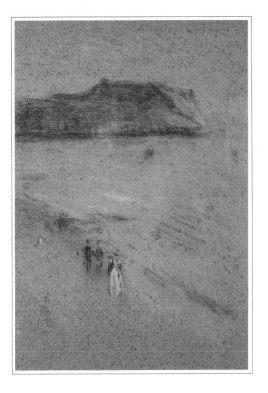

Purple and Rose:
The Lange Leizen
of the Six Marks

Oil on canvas
1864
91.5 × 61.5 cm

Before the art of Japan influenced
Whistler in a serious way, it already
provided decorative subject-matter.
The obscure title of this painting,
showing his mistress Jo Hifferman
posing as a potter, refers to the Dutch
name for the elongated figures ('long
Lizzies') painted on Japanese pots, and
the identifying marks of the potter.

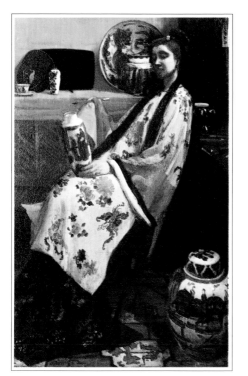

***Symphony in White,
No. 2: The Little
White Girl***

Oil on canvas
1864
76 × 51 cm

Following the stir created by *The White
Girl* at the 1863 Salon des Refusés,
Whistler had Jo Hifferman pose for a
second, subtler and more complex
'arrangement in white'. Her enigmatic
expression recalls portraits by
D. G. Rossetti, with whom Whistler
had recently become friendly, and
whose brother William reviewed the
painting favourably in 1865.

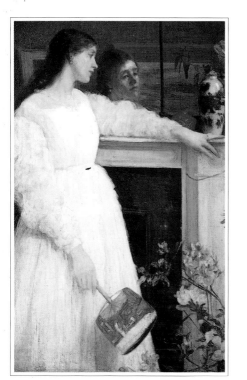

The Artist's Studio

Oil on wood panel
1865
62.2 × 46.3 cm

Inspired perhaps by Fantin-Latour's *Homage to Delacroix*, Whistler conceived a similar group portrait, to include his models and kindred spirits such as Albert Moore and Fantin-Latour himself. The painting never materialized, but this is one of two studies showing Whistler himself with two of his models.

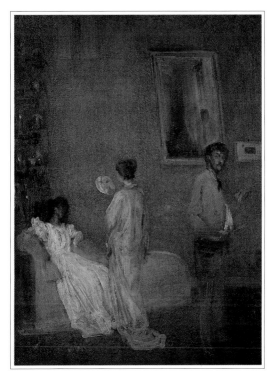

Nocturne in Blue and Gold: Valparaiso

Oil on canvas
1866
75.6 × 50.1 cm

On 31 June 1866, Whistler and his brother sailed to South America, apparently to bring his West Point experience to help Chile and Peru in their struggle against Spain. Little is known about his motives or movements, and he painted nothing except two atmospheric views of the harbour at Valparaiso.

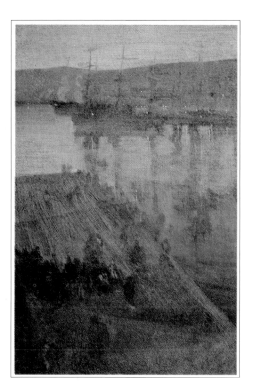

*Crepuscule in Flesh
Colour and Green:
Valparaiso*

Oil on canvas
1866
58.4 × 75.5 cm

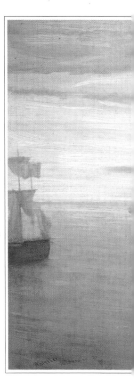

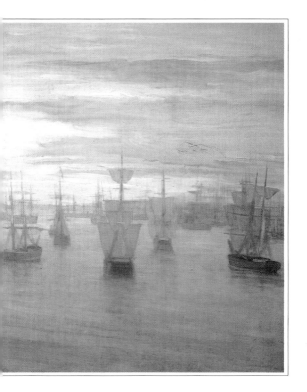

Previous page – Such is the serenity pervading this second view of the bay that, even with ships under sail, it is difficult to relate it to the impending bombardment of the city and the artist's subsequent retreat on horseback. Less difficult is to see the Valparaiso paintings as prefiguring Whistler's Thames nocturnes.

Symphony in White, No. 3

Oil on canvas
1867
52 × 76.5 cm

This lyrical third 'symphony' was in fact the first painting to be given a musical title by Whistler, who subsequently re-titled earlier works. He regarded it as an important step in his own development and sent it to Paris, to be seen by Degas and Fantin-Latour, before it was even exhibited.

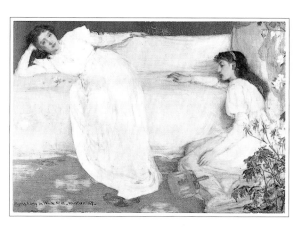

Symphony in White No III. Whistler 1867

Symphony in Blue and Pink

Oil on millboard, mounted on wood panel
c.1868
46.7 × 61.9 cm

The years 1868 and 1869 were a period of experiment for Whistler, during which he did not exhibit. Much of his time was spent on a series of figure paintings known as his 'Six Projects', first conceived as a decorative scheme for Frederick Leyland. In spite of prolonged effort and frequent reworking, however, none of these graceful compositions were ever finished.

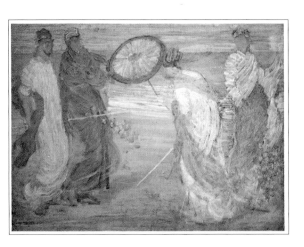

***The White
Symphony: Three
Girls***

Oil on millboard,
mounted on wood
panel
c.1868
46.4 × 61.6 cm

The poet Swinburne visited Whistler
while he was working on his sketches
for the series. *'In one,'* he wrote, *'a
sketch for the great picture, the soft brilliant
floor-work and wall-work of a garden
balcony serve ... to set forth the flowers and
figures of flowerlike women.'*

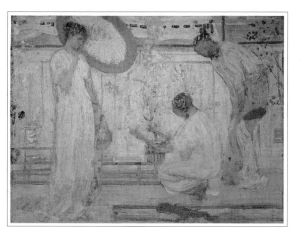

Harmony in Flesh Colour and Red

Oil on canvas
c.1869
38.7 × 35.5 cm

This small painting, a variation on the same theme as the 'Six Projects', was likewise left unfinished. In these attempts to achieve a synthesis of Japanese art and the decorative classical style of his friend Albert Moore, Whistler experienced feelings, rare for him, of inadequacy and self-doubt.

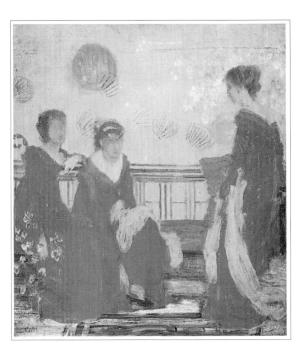

***Arrangement in
Grey and Black:
Portrait of the
Artist's Mother***

Oil on canvas
1871
144.3 × 162.5 cm

Whistler struggled – and his Protestant
mother posed – for three months
before he was satisfied with this
masterly portrait. He then wrote
revealingly: *'What can or ought the public
to care about the identity of the portrait? It
must stand or fall on its merits as an
"arrangement": and it very nearly fell –
that's a fact.'*

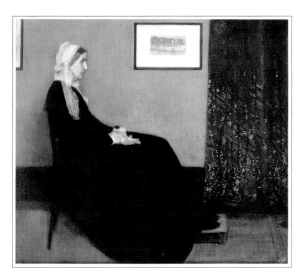

Arrangement in Grey: Portrait of the Painter

Oil on canvas
1872
74.9 × 53.3 cm

The portrait of his mother was Whistler's last submission to the Royal Academy, and only accepted after much debate. This self-portrait, which baffled old friends such as Fantin-Latour, was exhibited at Durand-Ruel's London gallery. It is one of the first paintings to bear the famous butterfly signature, loosely representing JW.

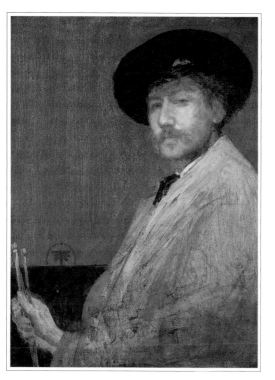

Harmony in Grey and Green: Miss Cicely Alexander

Oil on canvas
1872 – 3
190 × 98 cm

This charming portrait inspired George Moore to write: *'This picture seems to me the most beautiful in the world … this little girl is the very finest flower, and the culminating point of Mr Whistler's art. The eye travels over the canvas seeking a fault. In vain …'*

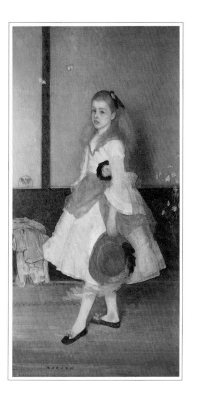

Nocturne: Blue and Gold – Old Battersea Bridge

Oil on canvas
1872 – 3
66.6 × 50.2 cm

The first of Whistler's atmospheric Thames paintings to be called a 'nocturne', *Old Battersea Bridge* is also the most overtly Japanese, its composition based on a Hiroshige print. Although the nocturnes, with their lightness of touch and subtlety of tone, look exquisite to modern eyes, Whistler guessed correctly that they would incense the critics, who duly condemned them for their lack of 'finish'.

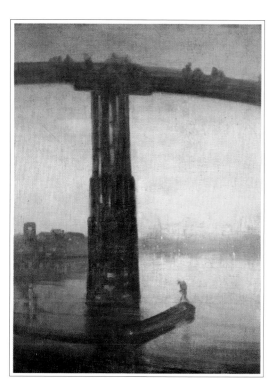

Nocturne in Black and Gold: The Falling Rocket

Oil on wood panel
1875
60.3 × 46.6 cm

This dazzling nocturne prompted Ruskin to write that he had *'never expected to hear a coxcomb ask two hundred guineas for flinging a pot of paint in the public's face'*. In court, pressed to confirm that he indeed asked this much for two days' work, Whistler made his immortal reply: *'No – I ask it for the knowledge of a lifetime.'*

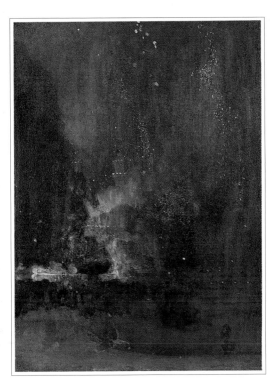

***Stormy Sunset,
Venice***

Pastel
1879 – 80
18.5 × 28.3 cm

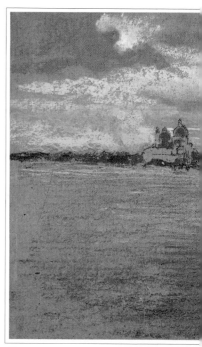

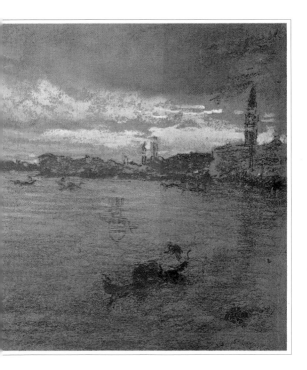

Previous page –In 1879, following the Ruskin trial and his bankruptcy proceedings, Whistler went to Venice to lick his wounds. Here he produced a series of etchings and about a hundred sketches in pastels – a medium he had previously used for rapid figure studies, but which now suited his mood and his subjects perfectly.

Little Canal, San Barnaba; Flesh Colour and Grey

Pastel
1879 – 80
25 × 15 cm

In Venice Whistler scarcely painted at all, but found great satisfaction in using pastels – and a store of coloured paper discovered in an old warehouse – to capture fleeting and intimate atmospheric effects. He would wander about on foot or by gondola, looking for subjects – and finding them around every corner.

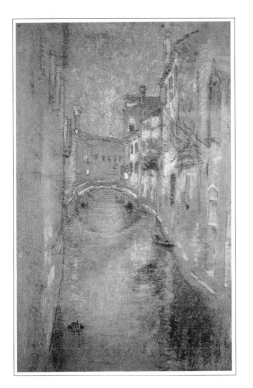

***Mother and Child
on a Couch***

Watercolour
1880s
19 × 26.6 cm

Whistler seldom painted in
watercolour, but used the medium
more frequently in later years, mainly
for landscapes. Here he applies it to
a subject he had previously tackled
in pastels, and achieves a similarly
sensuous delicacy with a limited range
of colour.

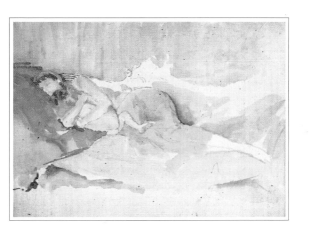

***The Little Rose
of Lyme Regis***

Oil on canvas
1895
51.4 × 31.1 cm

By the time he painted this enchanting
portrait of a blacksmith's daughter,
Whistler was at last receiving praise
from the critics. *'Nature,'* wrote one,
*'has endowed him with a divine gift for
seeing colour and harmonizing and
understanding both the beauty of form and
line, and of the whole composition – a
talent not seen since the art of Velasquez ...'*

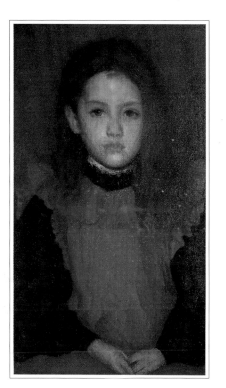

First published in Great Britain in 1995 by
Pavilion Books Limited
26 Upper Ground, London SE1 9PD
Copyright © Pavilion Books Limited 1995

Text by Steve Dobell
Designed by Andrew Barron & Collis Clements Associates
Picture Research by Lynda Marshall

A CIP catalogue record for this book is available from the
British Library

ISBN 1 85793 497 0

Printed and bound in Italy.
Typeset in Galliard

2 4 6 8 10 9 7 5 3 1

This book may be ordered by post direct from the publisher.
Please contact the Marketing Department.
But try your bookshop first.